T0020363

Hirst-isms

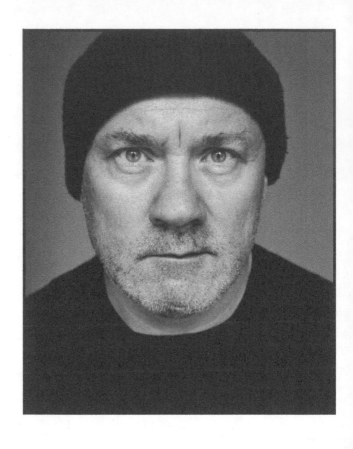

Hirst-isms

Damien Hirst

Edited by Larry Warsh

PRINCETON UNIVERSITY PRESS
Princeton and Oxford

in association with
No More Rulers

Published by Princeton University Press,
41 William Street, Princeton, New Jersey 08540
In the United Kingdom: Princeton University Press,
99 Banbury Road, Oxford OX2 6JX
press.princeton.edu
in association with
No More Rulers
nomorerulers.com
ISMs is a trademark of No More Rulers, Inc.

ISBN 9780691239859
Library of Congress Control Number 2022010922
British Library Cataloging-in-Publication Data is available

This book has been composed in Joanna MT
Printed on acid-free paper. ∞
Printed in the United States of America
3 5 7 9 10 8 6 4 2

CONTENTS

INTRODUCTION

A true maverick, Damien Hirst has not simply pushed the boundaries of what can be considered art, but he has disregarded them completely. He has defied art-historical placement within a genre or medium, utilizing materials from diamonds to flies—and everything in between. He has dissolved the boundaries between artist, celebrity, and entrepreneur, and has disrupted conventional perceptions of value, muddying the definitions of high and low art. And perhaps most profoundly, he has confronted us time and time again with subjects we all prefer to avoid: taboos, corruption, materialism, decay, and death.

Hirst grew up in Leeds, England, and was a rebellious teenager deeply influenced by the

British punk scene. From an early age his defiant and disruptive attitude not only steered him toward art but shaped his creative practice. At sixteen, he posed for a photograph with the severed head of a dead man in a morgue. At twenty-three, while a student at Goldsmiths College of Art in London, he curated an exhibition of work by fellow students and friends, including *Bullet Hole* (1988) by Mat Collishaw, a close-up photograph of an ice-pick wound to the head. The exhibition, titled *Freeze*, is now widely regarded as the launch point for the Young British Artists (YBAs) movement.

After *Freeze*, Hirst's work became even more provocative and disturbing. Soon after graduating from Goldsmiths, he created his pivotal installation *A Thousand Years* (1990), a glass box containing a rotting cow head surrounded by maggots and flies. He quickly caught the eye of

Charles Saatchi, who backed Hirst financially, resulting in his Natural History series. Notably, this series included *The Physical Impossibility of Death in the Mind of Someone Living* (1991), a fourteen-foot tiger shark suspended in a glass tank filled with formaldehyde. The work, which was shown in the first of a series of exhibitions titled *Young British Artists*, catapulted Hirst into the international spotlight.

Hirst has continued to challenge, intrigue, and baffle us with his controversial and frequently divisive artwork. But his masterful use of language is often overlooked. His poetic titles interact with the subjects of his work in compelling and playful ways, imbuing them with additional layers of meaning. The work entitled *Mother and Child (Divided)* (1993), for example, presents a cow and a calf, each dissected and halved, and preserved in formaldehyde. For the

Love of God (2007) is a platinum cast of a human skull encrusted with diamonds. *The Acquired Inability to Escape* (1991) consists of a vitrine containing a desk, chair, cigarettes, lighter, and ashtray.

Through Hirst's own words, this book offers a window into the mind of a complex and compelling artist. Collected from interviews, written works, and other primary sources, the quotes in these pages illuminate Hirst's insightful, bold, and at times surprising voice, delving into his formative years, his fascination with death, religion, and science, his artistic process, and his relationship to success.

Among the greatest gifts art can give us is the opportunity to think critically about our judgments, to engage with our own biases, and to sit with and examine our discomfort. Hirst demands this level of engagement and more. His work is at the same time cerebral and populist,

eliciting both intellectual and visceral responses from his viewers, often simultaneously. Marrying elegance and finesse with the shocking and grotesque, consistently making death—the great equalizer—a central theme, his work is among the most accessible of his generation. From his humble beginnings to his meteoric rise as a pioneer in contemporary art and culture, Hirst remains one of the most influential and boundary-defying artists of our time.

LARRY WARSH
NEW YORK CITY
JUNE 2022

Hirst-isms

Early Life and Family

I feel really lucky to be an artist. When I was a kid, I never even imagined that I'd ever get paid to do something I enjoyed. (3)

———

I remember my mum painting cherry blossoms in the garden, when I was five or six. She had an oil painting of a cherry blossom and I remember I tried to paint it; I think I ate some paint. (12)

———

You have to work out what you are, and I worked out I was all over the place. (13)

———

In the beginning I did little collages. ... I
loved arranging things. Then when I saw
[Francis] Bacon's paintings, I thought, "fuck
it"; I gave up, really, because I just thought
that was what I wanted to do. (4)

———

Your art has to be liked by children
or it's no good. (13)

———

My advisor [in school] said the greatest
idea in the twentieth century
was collage. (37)

———

I was a Catholic until I was twelve. Then my
parents got divorced and my mum left the
church. I loved the imagery: the blood. But
bring in God, and I turn into a scientist
and say there is no God. (24)

———

I lost my grandparents that I was quite close
to when I was about fifteen. I didn't realize
it at the time, but I talked a hell of a lot to
[my grandmother] about life. (26)

———

I originally wanted to be a deep-sea diver,
but then I found out about sharks. (13)

———

I thrive off other people. (29)

———

I like the way that you can divide relationships
into two piles; in and out of love. (11)

———

Art is the coward's way out, I think. If you put
what you put into art into other people, you'd
have a much fuller, more brilliant life. (27)

———

I've always considered myself to be an
infiltrator, and when I was younger I was
quite angry and out to prove a point.
But anger is worthless on its own—you
have to be able to adapt and pay
attention to what works. (21)

———

When you're young, you spend a lot of time discovering or creating a language for yourself, a visual language, but then after a while you realize there is no point carrying on doing that and you start to use the language [used by everyone else]. (5)

———

I always drew. I was always creating birthday presents. (37)

———

[My mother] loved art. She painted—she used to do life drawings and stuff—but she was always ashamed of them and said: "Don't look at that." (12)

———

I love the idea of a company, an old-fashioned company. I'm just an old-fashioned boy at heart, really. (1)

———

[With my family] it's a different kind [of love]. I can remember two things, one my grandmother said to me and one my mother said to me. I was about sixteen in the supermarket with my mother, it all seemed very alien to me (the supermarket and everyone's acceptance of it) I said to my mother "I don't really feel like I'm a part of all this" and she said "Neither do I"; I realized that no one did. And in a conversation with my grandmother, I said "I still feel as confused as when I was seven" and she said "So do I." Same thing. (11)

———

I love [being a father], yes. It's amazing.
It connects your whole life. You see the
beginning of your life through your kid's
life, because you missed the first bit
because you were too young. (13)

———

I've got a child who draws fucking superb.
Scared the hell out of me. (29)

———

All children draw, and for some reason
most of them stop. (37)

Art and Life

I'm interested in the confusion between art and life; I like it when the world gets in the way. (5)

———

Art can get to anyone. (29)

———

Humans need art. People who haven't been born yet will decide what's relevant, and artists today just have to try to make art that you think is relevant. (13)

———

You don't realize it, but the whole history of art came out of books and reproduced images. (28)

———

I always thought that the art exists somewhere between the icon and the reproductions. It is not just the icon and it's not just the reproductions. It's something in the middle. (13)

———

Art stops you in your tracks, no matter who you are. (29)

———

There's a massive amount of freedom in art ... you can get away with murder. (28)

———

Artists do everything better. Artists do *everything* better. A great accountant's an artist; a great bricklayer's an artist; a great plasterer who signs the fucking wall before you paint it ... Artists. They're the greatest things in the fucking world. (29)

———

You forget everything when you're in front of a great painting. (4)

———

There are two things in an artwork. There's
a visual thing and there's a cerebral thing;
there's a mind thing and an eye thing going
on. And the mind thing is always secondary:
no matter how great or important conceptual
art is, at the end of the day, it's secondary
to the eye thing. (1)

———

I sometimes imagine that the spot paintings
are what my art looks like under the
microscope. The difference between art and
life is the difference between cells in the real
world and the spot paintings. (11)

———

Every artwork is fundamentally
the same thing. (1)

I like that sort of confusion where you're
not sure where the art is. You know, it
makes it kind of fresh. (37)

Genius means that everybody isn't an artist.
Freedom means that everybody is an artist.
I believe in freedom. I don't believe
in genius. (34)

Art came out of the desire to make your
habitat more interesting. I love that. (1)

Art and images can make you desire the craziest things—desiring art is crazy. (2)

———

I like to imagine that art is more theatrical than real. (10)

———

Art works. It exists. It seems like every other medium—like music, like writing—has been caned into shape by other people. But art, still, even today, has been left running riot. (28)

———

I love objects; I love color; I love images. I give art a very fucking hard time. But I love making a go of it. (29)

The whole world is so crazy today that
it's very hard to make art that's a reflection
of that using only paints and canvases.
But it keeps changing. (13)

———

In my mind I think that art's immortal, but
maybe it has a limited lifespan. All these old
masters are falling apart, and we're clinging
onto them through preservation. It's like in
that film of H. G. Wells's *The Time Machine*,
when the books fall apart in his hands. (1)

———

Maybe art is like true love; maybe it never
dies. That's my hope, anyway. (1)

———

If you're gonna pray, why not pray to art?
Art won't let you down. (3)

———

Art's got the aura because people are
prepared to hold it close to them for
thousands of years. (32)

———

I think there are three dim words in life and
they're used to connect people to other
people; "Art," "God," and "Love." (37)

———

It is hard to say I do not believe in God. I
believe in art because it is very similar. (38)

———

Art is probably the most valuable currency in the world, and painting is the best level of art. (7)

Being a painter, I've always thought, is better than being an artist or a sculptor. (4)

Cut back art to its basic level and it's painting. It's just you in a little room with some canvas and some paints. (13)

Now that images have been airbrushed, people have gone back to painting. It's the only kind of imagery that makes any attempt at honesty. (7)

———

I think art gets boring pretty fast, and to give it relevance today is pretty difficult; you've got to catch people out visually. (6)

———

Art allows you to go off on the wrong track without going mad!—That's an artistic statement. (9)

———

Anything done well is art. (13)

———

I can't understand why some people believe
completely in medicine and not in art,
without questioning either. (11)

———

[The Medicine Cabinets series] came out
of an urge to make art that everybody could
believe in, even my mother, people who
hate art, modern art. (11)

———

I've always really loved this idea of art maybe, you know, curing people. (26)

On the one hand I want to be an artist and on the other I want to be realistic. There's a clash somewhere and a feeling in me that I can't override; the more I try to escape it the more deviously it evades me, it's an inescapable situation. (11)

If I follow my ideas about art through to their final conclusion I realize I shouldn't make art, but I still do. (11)

I make art; I try to make it alive. I know it's
impossible. I also know it's impossible for
me to not try and I enjoy this dilemma
because it doesn't stop me. (11)

———

I want to make art, create objects that will
have meaning forever. It's a big ambition,
universal truth, but somebody's gotta do it.
(18)

———

Art seems to me to be about life. If art wasn't
around we'd still have life but if life wasn't
here you could forget about the art so I find
it difficult to believe in art. (11)

———

For me it's as if the artist is the animal and the painting is the record of the artist's tracks through space and time. (23)

———

If you make good art people will want it; you just have to believe that. And even if they don't, you can't really think too much about buyers because you're making art for people who haven't been born yet, in a way. (12)

———

Though a lot of VR [virtual reality] art really leaves me cold, I think there is something exciting potentially there. (17)

———

There's a fear that in dark times art becomes irrelevant, but maybe it's more relevant. (14)

———

Making art, good art, is always a struggle. It can make you happy when you pull it off. There's no better feeling. It's beauteous. But it's always about hard work and inspiration and sweat and good ideas. (18)

———

To be weak publicly is a great way to make art. (33)

———

At the end of the day, with all good art
I always want to feel something about
my existence. (26)

———

Art is like a map of a person's life and I am
definitely a chameleon. (5)

———

If I believe in art as much as I say I do
I'm lying; but I do. (11)

———

Somehow people put up a wall with art,
for some reason. (37)

———

Good art is always very simple. (1)

———

At the end of the day, what's art about? It's
about life, and it's always been about life. (26)

———

It's a big responsibility being an artist. (37)

———

Influences and Heroes

I have always loved horror films;
I like being frightened. (16)

———

[John Hoyland] was the first artist that
blew my mind. (12)

———

[Pierre] Bonnard was absolutely an inspiration
for the *Veils*. I went to see a show when
I was really young. (12)

———

Peter Blake's a hero. He's one of my heroes from when I was a kid. Before Gilbert and George and all that. Before even Bacon. (32)

There are a helluva lot of people living in my head, most of them nuts. (2)

I see expressionism and minimalism together, like two sides of a coin. (23)

The greatest artwork I've seen in a while is the banana taped to the wall by [Maurizio] Cattelan. I love it ... because it's provocative. And you forget you can still do that today. (13)

———

As a kid, the [Francis] Bacon screaming heads ... the nightmare spaces and the violence. I was always into that. (4)

———

Bacon's like: It's a doorway, it's a window; it's two-dimensional, it's three-dimensional; he's thinking about the glass reflecting. ...
It's his guts. (28)

———

[Bacon] can't paint, and he admits it. And it's
the most powerful position you can ever have.
(28)

The horror in [Francis] Bacon is biological.
It's like touching something. (6)

Before I went to art school I came across the
best artist ever in the history of the world, and
that was [my neighbor] Mr. Barnes. And no
one else saw it. The best ever artist you could
ever hope to get. If you believe in the integrity
of art and the belief of it coming from inside
yourself and being a great thing, I found
the best at the beginning. (27)

I was taught by a '50s painter in Leeds called
Patrick Oliver, who was a bit like Peter
Lanyon. He believed in paint[ing] how you
feel. Browns and sombres if you're feeling
dark, reds and yellows if you're feeling happy.
He would say what a real painter does
is gestural and big. (13)

———

I think [the punk] attitude crept into my art
somehow. I was always looking for ways to
sneak stuff into the art world and make it
explode in their faces. (18)

The whole thing that got me really with the Sex Pistols was it seemed like the world had exploded. People went mental. (40)

———

I like the messier painters: Rembrandt, Goya, Titian, Soutine. (12)

———

Bernini. Michelangelo. I mean, they stand above everyone else, really. (12)

———

If you look at Ellsworth Kelly's paintings … you think: "My god, this is like a sunny day inside a room." (37)

———

I really love Bruce Nauman. (37)

I had an idea for a great artwork, where you go into a gallery and there's a plinth with a big red button on it that says "Do Not Touch." And if you touch it, a boxing glove comes out and smashes you in the face. And I think a lot of Bruce Nauman's work does that. (37)

I took science in the way that Picasso took the bike seat and the handlebars and made the bull's head. I mean, there's nothing complicated about it. Science seemed to be getting people's attention and art didn't, so I hitched a ride on that. (1)

With Picasso, maybe the talent is a little too apparent. I don't know. Picasso became his own idea of himself; he created a persona and he lived it, whereas the Beatles split at the height of their fucking success, which is a phenomenal thing to do. (1)

John Lennon's my only hero. (27)

Warhol's great. You can't argue with it. It's simple. And visually great. It's easy, cheap, simple. He certainly doesn't over-complicate things. (1)

Jeff [Koons] is the perfect artist to follow
Warhol. He's America today. (13)

———

My mum's quite artistic. She used to
have a florist shop. (26)

———

I love [Joan] Miró; Miró's sculpture
is just brilliant. (4)

———

I always liked minimalism; [Donald] Judd,
[Sol] LeWitt, all those guys. I loved the idea
of minimalism as a force against life or God
or something like that. You don't get
geometry in life. (5)

For me minimalism represents some kind
of logic. Like a medical logic, it's like the idea
of perfect formalism on the one hand
and on the other hand you are falling
apart yourself. (23)

———

I always believe in contradiction, compromise.
… It's unavoidable. In life it can be positive
or negative, like saying: "I can't live
without you." (23)

Myths are often about the inescapable, about the painful discovery of powerful constraints. They don't tend to be stories about people who get away with things, but rather stories about people who try to; people whose transgressions turn out to be a lesson for us all. Oedipus, Prometheus, Narcissus, and Antigone all, in their different ways, suffer the most violent of all sentimental educations. (8)

I'm more convinced by the Beatles than Picasso these days. (1)

Motivation

If somebody says you can't do something,
I want to find out why you can't at least,
and often you find out that there is no
reason why you can't. (13)

———

Nothing is a problem for me. (37)

———

If you believe that failure isn't an option,
then it isn't an option. (5)

———

When you're young, you're invincible, you're immortal—or at least you think you are. The possibilities are limitless, you're inventing the future. Then you get older and suddenly you have a history. It's fixed. You can't change anything. (18)

———

I just like doing what you're not supposed to do, [and] what you're not allowed to do as well. I like breaking the rules.
I like to misbehave. (13)

———

[I] want to set up triggers that create thought. (37)

———

I think artists have always had this dilemma,
which is to move forward. But you always
want to be great in terms of what went
just before. (28)

———

I always try and think that I make art
for people who haven't been born yet.
That's my audience. (13)

———

The world's constantly changing. If you
make art that is about the world today[,] it is
not going to be about the world tomorrow.
I think you've got to change.
You keep changing. (13)

———

There's a world of difference between
need and desire. (2)

Everything I do is a celebration, at the very
least it's a celebration. (10)

I want a scene. I've always wanted a scenario.
I want a situation. (35)

I love the way that art doesn't really affect
the world. Science affects the world much
more directly. I don't want to affect the
world that directly. I want to affect
the world obliquely. (35)

I always try out everything before I show it to some extent. And I'm always aware that, even if it doesn't work, it's going to be seen only in a good way; that at least I made the effort to make it work. (26)

———

I just like the idea of painting and making it difficult for yourself. (26)

———

I want to push people to thinking ahead; to think more than they might think they're capable of. I want to get them to the limit, but I don't want to get them beyond that. (26)

———

For me, the commerce side of art, you know, the idea that you are not just making a painting but you can be changing the world, changing the way people perceive the world and when you are actually making art and you're seeing it on adverts and TV and Paperchase and people are buying wallpaper with your dot paintings on it, that makes me feel alive. (5)

———

Art's my thing. It's the structure of who I am. And you can't unwind that. Because if you unwind that, you unwind me. (29)

You can't be a good artist and lie. You can't be a liar. Whatever's happening to you is what's happening to you. And whatever's happening to you, you've got to communicate. (29)

———

The tragedy of the world is that the good can't be bothered and the bad can. (8)

———

I believe there's an infinite number of ways to get to the same point. (37)

———

Sometimes you have to step over the edge to know where it is. (14)

———

Process and Production

When I started painting, I enjoyed the process
more than the end result. (23)

———

The whole idea of art is about fifty-fifty.
You and me equal together.
Viewer and object. (28)

———

Originally I wanted to be a painter, but I could
never do it, because [of] the idea of a painting
being like a void. I could never decide what to
put in the picture or where, given the infinite
mass of possibilities and places. (23)

———

Color is a good way to avoid darkness. (12)

———

I think I've always been afraid of painting,
really. Right from the beginning. (16)

———

I see a painting as a kind of sculptural object.
(13)

———

With painting, at the end of the day, you
look at it and it's fantastic. And the next
morning ... you wake up, and it's still
the same and it's depressing. (23)

———

I look for universal triggers. I mean, slipping on a banana [peel] is funny in any culture; always has been and always will be. As an artist I always look for things like that. (3)

———

You make art from what's around you. With a tube of paint the possibilities are endless. Whereas a block of wood has history. (20)

———

I'd always wanted to do a work with sharks. ... They've got this really kind of powerful horror. (26)

I'm not a violent person. But I definitely wrestle with violent images, in a huge way. I get *excited* by violent imagery. (32)

I remember becoming very depressed when I looked at a brain and it did not have compartments that showed anything. It's like an airplane, unbelievably marvelous and yet very crude in another way. (23)

When you put most things together formally in unexpected ways, you can arrive at the big issues: sex, death, life, religion, beauty, science. Love is kind of it. There are no other big subjects, really, and you can cover it all with a jar of Vaseline and a cucumber. (6)

———

I like the violence of inanimate objects. (23)

———

You get two objects that on their own don't mean anything, and you put them together and you can create. All hell breaks loose. (37)

I enjoy strategies if you can get away with it. (33)

I think sensationalism is only an element in a composition, and I don't think if you're making a composition you should overlook it. (26)

The great thing about drawing is it's cheap, so you can visualize very expensive ideas and things very cheaply while you're on the pencil-and-paper stage. If you want to do a very expensive sculpture, it's very good to start with drawing. (13)

I can work out in a few lines with a pencil
on a piece of paper how big I need to
make a tank. (1)

———

When I can't afford to make pieces, I get
models made and have drawings done
and work it out. (26)

———

I want [the spot paintings] to look like they've
been made by a person trying to paint like a
machine. I sometimes feel that I'm trying to
be a machine. (11)

———

A lot of people say when you make art in a factory it's a negative thing, but factories can make great things as well as bad things. A factory kills chickens and it's shit, but a factory makes Ferraris and it's amazing. (13)

———

If I couldn't delegate I wouldn't make any work. (15)

———

You get some sort of security from the repetition of a series. If you say something twice, it's pretty convincing. It's more convincing than if you say it once. (1)

———

People are afraid of change, so you create a
kind of belief for them through repetition.
It's like breathing. (1)

———

I think that individuality is a confusing thing,
so to get rid of that visually is quite exciting.
(23)

———

I just want to get a viewer involved, all
viewers. I try to say and deny many things to
imply meaning, so that when you work out
a reading you implicate yourself. (11)

———

I've always been drawn to series and pairs.
A unique thing is quite a frightening object.
(1)

———

I like it when there is more than one way
of saying something. Like songs in
an album. (39)

———

The spot paintings always surprise me.
There's so little there but it looks so vibrant
on the wall. (10)

———

[Glass is] an amazing material; it's something
solid yet ephemeral. It's dangerous as well. ...
And it's a way to separate people but engage
them. You can invite them in and keep them
away at the same time. (1)

———

If I have problems with selection in what
I'm doing I'll become instinctive, and
if I have problems instinctively
I'll become intellectual. (26)

———

I think as soon as the elements [of an artwork]
are organized, I can arrange them in really
poetic ways, and say what I want to say. (26)

I like the changing life of the spot paintings:
the product changes, the scale changes, the
color changes but the form does not. (23)

Imagine a world of spots. Every time I do a
painting a square is cut out. They regenerate.
They're all connected. (10)

I have one rule: Whatever I'm painting,
I always imagine that if I die in the middle
of it, it's got to look good. (4)

It's an amazing fact that all objects leap
beyond their own dimension. (19)

———

I *sneak* myself into my work, definitely.
Because I believe in those kind of very human,
abstract expressionist, paint-how-you-feel
ideas. I can't get rid of those ideas. I've tried.
And the more I try, the more they come
out in ways I don't expect. (26)

———

You kind of claim the gallery space with a box. Wherever you put this, you can have any other sculpture next to it and it's kind of claimed its own space. (5)

I still believe that the way to get any artist to do anything is [with] a great space. (13)

As an artist, there's a concrete visual language
that exists for me, which is sometimes
universal. I feel I can communicate with that
more than with anything else. I remember
seeing dog shit in the street in New York, with
a cigarette butted out in it that had lipstick on
it. … For some reason, some woman couldn't
butt her cigarette out on the street so she just
stuck it into dog shit. It's unbelievable.
So I'm always looking for things like
that, whatever they mean. (6)

———

As the things we use are increasingly the
product of complex industrial processes,
we lose touch with the underlying reality
of the goods we consume. (8)

———

Mass production hides natural differences
between things. (10)

———

I'm a theatrical artist. If someone says to me,
"You can make that out of polystyrene and
it'll look like steel," I'll do it. (33)

———

I'm aware that a lot of the things I make at
the moment are kind of the same idea.
I worry about that. I mean, I don't want
to make "Damien Hirsts." (26)

———

Behind you is your history, a trail which
is impossible to avoid. Then there are infinite
possibilities ahead. So the question of series
becomes problematic. I could make pets
in formaldehyde for the rest of my life,
but I won't. (10)

———

I can't imagine not having ideas. At all.
But I suppose you deal with it when it comes.
(26)

———

I try to make work that is really recognizable.
(13)

———

Success and Fame

Being best is a false goal, you have to measure success on your own terms. (18)

I've always tried to ignore the money and focus on the art. (7)

Money is massive. I don't think it should ever be the goal, but I had no money as a kid and so I was maybe a bit more motivated than the rest. (18)

There was a time when I didn't have a studio
and I used to love the pressure. (12)

———

If everybody's telling you you're brilliant,
you're already halfway to turning into
an asshole. (26)

———

I learned early on that rebellion doesn't
matter when it comes to the market, but I
do think that punk attitude has
influenced my work. (21)

———

Once you get attention—once you get famous—people don't want dialogue. People don't want to fucking know what your work's about. They want to climb on board, get involved and have a piece of it. They don't really want to know what you're actually driving at. (25)

———

Obviously it's appealing. To be a ... star. If you say it isn't, you're lying. (26)

———

A lot of people have opinions about what you do by reading about it. (37)

———

I think, with a lot of painters, you shouldn't expect them to be able to talk about the work. ... I think when you start to get successful there's a massive problem where you can't help but get smug. (26)

———

If it's a good idea, then lots of people have had it before. (16)

———

I sometimes think with all this success comes too much responsibility; I kind of think I have to reinvent myself every day, and then you've always got to ask yourself: "In whose terms am I successful?" And ask yourself: "Is that good?" 'Cause there's so many ways to measure success. A lot of them bad. (3)

———

I had a desire when I was young to be famous. And I can either lie to myself and deny that, or I can accept it and realize that art is bigger than that. (27)

———

You have to get people listening to you before
you can change their minds. And I believe
that. You've got to *become* a celebrity before
you can undermine it, and take it apart, and
show people that there's no difference
between celebrities and real life. (27)

When I first bought a roll of bubble wrap,
that was the most famous I felt ... [when]
I worked at Anthony d'Offay, and they threw
away bubble wrap. ... How can you throw it
away? It's forty pounds a roll. I needed to get
it out of the bin and fold it up and take
it home to wrap up my work. (13)

Money is a tool. It works like a key,
and you run into problems when the tool
is overworshipped. (8)

———

I'm the creative guy, I'm an artist, I have
no idea about money. (15)

———

To have money, you have to respect it.
That's the main thing. (13)

———

What can you pit against death?
Money, apparently. (19)

———

There are a lot of people who like money
but who don't like art. (16)

———

There's as many art markets as artists,
aren't there? (26)

———

In terms of consumerism and all that sort
of stuff, art has been in a constant battle
for hundreds of years with every
other kind of image making.
We're fighting it today. (1)

———

I've always believed that art's more powerful and important than money, but it gets fucking close sometimes, and you just have to stay open to the fact that if you decide money's more important you have to stop doing it. (7)

———

I find the money aspect of the work part of its life. If the art's about life, which it inevitably is, and then people buy it and pay money for it and it becomes a commodity and manages to still stay art, I find that really exciting. (26)

The money men will tell you anything
to not have you realize that their real
motivation is cash. (8)

———

What's the difference between an art
dealer and art; a car dealer and cars; a drug
dealer and drugs; a politician and politics?
The four are the same fucking things
and the list don't end there. (8)

———

I look at people who have big businesses, and they are fucking mean. They run them like tyrants, treating people like shit, so everybody is on their toes, trying to please. And they are very successful businesses. But I've never done it that way. I always try to make everyone mellow down—make sure everybody's happy. The people I have employed have always kind of stayed with us. (16)

———

Once money became a "universal equivalent,"
against which everything in our lives is
measured, things lost their material reality
(real-world uses, the sweat and tears of the
laborer). We began even to think of our own
lives in terms of money rather than in terms
of the real things we hold in our hands:
How much is my time worth? How
does my conspicuous consumption
define me as a person? (8)

———

Buying something because you like it is the best investment anyone can make. (8)

––––––

I think people always buy good art. (26)

––––––

I've got collectors who have never been to either of my galleries. Which is fantastic! (16)

––––––

I also like the way [Andy Warhol] dealt with money, because he made it OK for artists to make money and he made it OK for a factory or a studio. That was a big change in the world. (13)

––––––

If you're an artist, you can make art about
anything, so you shouldn't be inhibited when
money's around. If it's easier when you
have no money, it becomes a kind of
illusion of something. (13)

Saatchi was really good for me. The best
thing for me was that I first saw the Saatchi
Gallery when I was just a student, and I
wanted to show there. To achieve that
dream was amazing. (13)

I loved the myth of Saatchi,
before I met him. (13)

My mum decided she understood my work
when Saatchi bought it. And I had a choice.
I could have either gone: "Well, that's my
mum. She understood my work because
she understood it at that point." Or: "She
understood it because Saatchi bought it." (27)

———

[Larry Gagosian's] spaces were like
supermarkets for art and I loved that. (13)

———

Being a famous artist is not all great. ... It's a
distraction, something you have to keep an
eye on and make sure that you don't get
things mixed up. It's very easy to
mix things up. (13)

———

It's a lot easier for artists to make art
when there's no money coming in—when
times are bad. (2)

———

I'd rather have mixed reviews than all bad
or all good. I quite like it when there are
debates, when somebody hates you
and somebody loves you. (13)

———

I like it when people love my art. I like it
when people hate my art. I just don't want
them to ignore my art. (24)

———

I think the world is complicated, so as an artist you're going to present it in a complicated way. (37)

———

I'm interested in how an artwork moves through a career, through finance, that kind of life as much as the more formal aspects of movement. (23)

———

People want to be in control. And in the world I don't think you can be in control. Things pop up and disappear all the time. (26)

———

People change and art changes. To stay relevant isn't as important to me now as it has been in the past, but it's comforting. (21)

———

Art's about life. And the art world's about money. And if art's about life, then there isn't anything else. (37)

———

One thing that my art's got to be is a map of my life, and then it's not for me to decide whether I survive or fail. (13)

———

The less I feel like an artist, the better I feel.
(26)

———

I think it's easier to make art when
you're not famous than it is when
you're famous. (13)

———

I still believe art is more powerful
than money. (18)

———

Life and Death

Life's infinitely more exciting than art. (11)

I think about life and death on every level. (26)

I like the action of nature, how it
creates things. (15)

I've always been interested in life, that's why
I use the dead animals, to make them real,
to make art that lives. (36)

I always felt that art was about life. All my favorite artworks, like *Saturn Devouring One of His Children* by Goya, and Francis Bacon, deal with this, so I think I've always felt that I need to be addressing this kind of stuff. (6)

———

The horrible things in life make the beautiful things possible and more beautiful. (11)

———

You spend 20 years celebrating your immortality, and then you realize that's not what it's about. (18)

I used to believe I was going to live forever.
And then you suddenly become aware that
you're not. You're celebrating the fact that
nothing can stop you. (16)

———

Every day your relationship with
death changes. (16)

———

On the whole, we sweep death under
the carpet. (37)

———

I don't think death exists in life. (37)

———

Death is an unacceptable idea, so the only
way to deal with it is to be detached
or amused. (22)

———

I want the world to be solid. But it's so
fluid and there's absolutely nothing you
can do about it. (26)

———

I think life is death because the excitement
of life is death. There isn't anything else, and
it can be taken away at any moment
unexpectedly. (13)

———

I love … science museums, natural history
museums, anything that takes your mind off
death, really, or focuses your mind on it. I love
all that hands-on stuff. It's great when you
feel that you're being entertained and also
educated. I've always felt if you could do
that with art it would be great. (1)

———

The whole story of [science], alchemy and everything; it's fantastic. Trying to understand the world, looking for the keys to understanding: that's what artists do as well in some ways. It's like God should be, the way they sell you the pills, the forms, the utopia, the hope, the cure. (1)

———

Science is a religion that declares it can stop death. In my opinion, science offers us immortality and religion offers us the afterlife. Although, in the end, they are both bullshit. As for art, it doesn't offer you anything you do not have, it offers you something that already lives inside you. That is the difference between art, science, and religion. (38)

———

I had an idea I wanted to do a zoo of dead animals, because when I was younger I loved zoos, but then I realized that the animals are all miserable. (13)

If you look at my cows cut-up in formaldehyde, they have more personality than any cows walking about in fields. That's another reason people get annoyed; it's easy to walk into a butcher's shop and see meat because meat is associated with life. But try to put that back together, back into a cow. It's the banal animal that gives it the emotion. You wouldn't feel the same about a tiger. (10)

I like the old ideas, life and death, good versus
evil, hot and cold, love, sex, death, desire.
All the big ideas, romance. (3)

———

Death does become surreal. It's like a kind
of dance, isn't it? You can get a glimpse of it.
It leaves you with a way of coming to terms
with something, hovering about on the edges
of it. Hopefully, thinking about it makes you
live your life more fully. (6)

———

I think I've got an obsession with death,
but I think it's like a celebration of life rather
than something morbid. You can't have
one without the other. (26)

I don't think death really exists in life.
I think the only thing that exists is
an obsession with it. (26)

I think the only way to deal with the subject
[of death] is through metaphor. (23)

People use [death] to sell us everything. In every Hollywood movie, there are thousands of deaths and dying and blood and gore and horror, but you use it in art and people are suddenly shocked. People love "death," they just don't like real death, and just because art is supposed to be real then I guess that death in art can feel unpalatable. (6)

———

I think that it's important to face the inevitable. Life's natural—you know it is—so death must be natural. (6)

———

Your soul is part of the thing that lives after you die. Which is more you than everybody else is themselves. (32)

———

I am aware of mental contradictions in everything, like: I am going to die and I want to live forever. I can't escape the fact and I can't let go of the desire, it's probably caused by images. (11)

———

[I'm obsessed with] the idea that medicines can somehow give you immortality, which they can't. I love the conundrum. I love what we do culturally. We believe doctors and we don't believe artists. (13)

———

A piece of artwork can continue saving lives after a person's died. By giving people hope and reasons to live. (13)

———

There's life and death in everything, isn't there? (12)

———

We're all weeping babies underneath. (9)

———

I used to think that you could make art about
death, but I don't think you can anymore.
Death is not art because art is life. (38)

———

Art deals with death. I think art is a light
in the darkness. (38)

———

SOURCES

1. Ulrich Obrist, Hans. "An Interview." February 2007. https://www.damienhirst.com/texts/20071/feb—huo.

2. Prince, Richard, and Damien Hirst. "A Conversation." January 2009. https://www.damienhirst.com/texts /2009/jan--richard-prince.

3. Murakami, Takashi, and Damien Hirst. "A Conversation." February 2009. https://www.damienhirst.com/texts /2009/feb--takashi-murakami.

4. Hoyland, John, and Damien Hirst. "Hoyland and Hirst." *RA Magazine*. Autumn 2009. http://www.johnhoyland .com/hoyland-and.

5. Marlow, Tim. "Interview with Damien Hirst." 2008. https://www.damienhirst.com/texts/2008/tim -marlow-beautiful-auction.

6. Hirst, Damien. "LEVIATHAN: A Conversation with Damien Hirst and John Gray." In *Corpus: Damien Hirst; Drawings*, 1981–2006. New York: Gagosian Gallery / London: Other Criteria, 2007, 29–41.

7. Welsh, Irvine, and Damien Hirst. "A Conversation— Damien Hirst." March 2004. https://www.damienhirst .com/texts/2004/march--irvine-welsh.

8. Hirst, Damien. "Why Cunts Sell Shit to Fools." January 2004. https://www.damienhirst.com/texts/2004/jan--damien-hirst.

9. Hirst, Damien. "Artist's Statement." Originally published as part of an interview with Sarah Borruso. *Hotwired Magazine*. https://www.damienhirst.com/texts/1997/feb--sarah-borruso.

10. Morgan, Stuart, and Damien Hirst. "An Interview with Damien Hirst." January 1996. https://www.damienhirst.com/texts/1996/jan--stuart-morgan.

11. Calle, Sophie. "Damien Hirst & Sophie Calle." In *Internal Affairs*. London: Institute of Contemporary Art, 1991.

12. Cole, Alison. "Blossoming Artist: Damien Hirst on Returning to the Studio, Fluorescent Florals and the 'Muppets' in Government." *Art Newspaper*. May 1, 2019. https://www.theartnewspaper.com/interview/blossoming-artist-exclusive-interview-with-damien-hirst.

13. Elkann, Alain. "Damien Hirst." Alain Elkann Interviews. March 22, 2020. https://www.alainelkanninterviews.com/damien-hirst/.

14. Rea, Naomi. "Damien Hirst Really Wants to Work with Plutonium and 11 Other Revelations from His Epic Instagram Interview with Himself." *Artnet News*. April 16, 2020. https://news.artnet.com/art-world/damien-hirst-answers-98-questions-instagram-1835844.

15. Hodgkinson, Tom. "Interview: Damien Hirst." *Idler Magazine.* February 28, 2020. https://www.idler.co.uk /article/interview-damien-hirst/

16. Haden-Guest, Anthony. "Damien Hirst." *Interview Magazine.* November 23, 2008. https://www.interviewmagazine .com/art/damien-hirst.

17. Curtis, Nick. "Damien Hirst Interview: 'I thought museums were for dead artists, and I wanted to look forward.'" *Evening Standard.* October 8, 2020. https://www.standard .co.uk/culture/damien-hirst-interview-exhibition-london -a4566181.html.

18. O'Hagan, Sean. "Damien Hirst: 'I still believe art is more powerful than money.'" *Guardian.* March 11, 2012. https: //www.theguardian.com/artanddesign/2012/mar/11 /damien-hirst-tate-retrospective-interview.

19. Greenberger, Alex. "Death, Resurrection, and Catharsis in Damien Hirst." *Artspace.* June 3, 2013. https://www. artspace.com/magazine/interviews_features/close_look /close_look_damien_hirst-51266.

20. Serota, Nicholas. "Nicholas Serota Interviews Damien Hirst." In *Damien Hirst.* London: Tate Publishing, 2012, 91–99.

21. O'Hagan, Sean. "Damien Hirst: Life and Death, Beauty and Horror." *NZ Herald.* March 16, 2021. https:// www.nzherald.co.nz/lifestyle/damien-hirst-life-and -death-beauty-and-horror-photos /4Q5X5YKIXWPKY8V6PWPNQBCIAA/.

22. Somers, Thierry. "Damien Hirst at Tate Modern." *200 Percent*. https://200-percent.com/damien-hirst-at-tate-modern/.

23. Cone, Michèle C. "An Interview with Damien Hirst." December 14, 1992.

24. Jones, Jonathan. "Damien Hirst: 'I flirted with the idea of pickling people.'" *Guardian*. February 18, 2021. https://www.theguardian.com/artanddesign/2021/feb/18/damien-hirst-i-flirted-with-the-idea-of-pickling-people.

25. Burn, Gordon, and Damien Hirst. "Introduction." In *On the Way to Work*. London: Faber, 2001.

26. Burn, Gordon, and Damien Hirst. "Interview 1." In *On the Way to Work*. London: Faber, 2001.

27. Burn, Gordon, and Damien Hirst. "Interview 2." In *On the Way to Work*. London: Faber, 2001.

28. Burn, Gordon, and Damien Hirst. "Interview 3." In *On the Way to Work*. London: Faber, 2001.

29. Burn, Gordon, and Damien Hirst. "Interview 4." In *On the Way to Work*. London: Faber, 2001.

30. Burn, Gordon, and Damien Hirst. "Interview 5." In *On the Way to Work*. London: Faber, 2001.

31. Burn, Gordon, and Damien Hirst. "Interview 6." In *On the Way to Work*. London: Faber, 2001.

32. Burn, Gordon, and Damien Hirst. "Interview 7." In *On the Way to Work*. London: Faber, 2001.

33. Burn, Gordon, and Damien Hirst. "Interview 8."
In On the Way to Work. London: Faber, 2001.

34 Burn, Gordon, and Damien Hirst. "Interview 10."
In On the Way to Work. London: Faber, 2001.

35. Burn, Gordon, and Damien Hirst. "Interview 11."
In On the Way to Work. London: Faber, 2001.

36. "Interview with Elena Geuna." In Relics. London: Other
Criteria, 2014

37. "Damien Hirst Interview." Charlie Rose. 2002. https:
//youtube/qx3EIOAfZHY.

38. Cué, Elena. "Interview with Damien Hirst." Alejandra de
Argos. November 8, 2021. https://www.alejandradeargos
.com/index.php/en/all-articles/21-guests-with-art
/41878-interview-with-damien-hirst.

39. D'Argenzio, Mirta. "Like People, Like Flies." In Damien Hirst:
The Agony and the Ecstasy; Selected Works from 1989 2004.
Napoli: Museo Archeologico Nazionale, 2004, 86–95.

40. Jones, Steve, and Damien Hirst. Damien Hirst: The Complete
Medicine Cabinets. London: Other Criteria / New York: L&M
Arts, 2010.

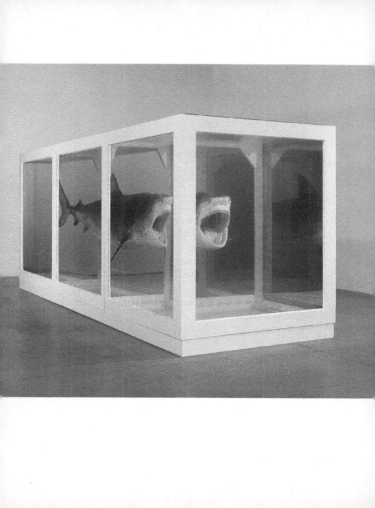

CHRONOLOGY

1965

Damien Steven Hirst (né Brennan) is born on June 7 in Bristol, England. Shortly after his birth, he moves to Leeds with his mother, Mary Brennan. He never meets his father.

Hirst grows up a rebellious child who early on develops an interest in science, medicine, death, and decay.

1981–84

Hirst visits the Leeds University Medical School's Anatomy Museum numerous times during these years. It is here that the photograph that will become *With Dead Head* (1991) is taken.

1983

Despite failing many of his classes, Hirst shows promise in art and drawing and attends a Foundation course at the Jacob Kramer College of Art in Leeds.

1984–87

Hirst moves to London and works on building sites. During this time, he begins working on a series of sculptural collages made from objects found in an abandoned house that belonged to his neighbor, Mr. Barnes.

1986

Hirst attends Goldsmiths College in London, gaining admission after submitting his portfolio of collages.

Later this year he begins working at the Anthony d'Offay Gallery, where he meets Andy Warhol, Anselm Kiefer, and Gerhard Richter, among other artists.

Also during this year, Hirst makes his first spot painting. The Spot Paintings, a series of consistent, hand-painted, colorful dots of various sizes and color palettes, would become one of his most prolific series.

1988

Hirst curates *Freeze*, an exhibition of work by his peers and friends at Goldsmiths College, including Sarah Lucas, Mat Collishaw, Fiona Rae, and Gary Hume. The exhibition takes place in an abandoned London Port Authority building in Surrey Docks, London, and is widely considered to be the launch of the Young British Artists (YBAs) movement. Hirst exhibits several works, including spot paintings, which he paints directly onto the walls of the exhibition space.

After the exhibition closes, Hirst and a few other artists continue to use the space as a studio.

Later this year, Hirst creates his first medicine cabinet in what would become his Medicine Cabinets sculpture series, which featured open shelves filled with various boxes, bottles, and jars of pills and other treatments.

1989

Hirst exhibits four medicine cabinets and three early
collages as his degree show. He graduates with a BA
in Fine Art.

1990

Hirst curates *Modern Medicine*, a group exhibition at
Building One in London, with Carl Freedman and
Billee Sellman.
Later this year he creates the sculptures *A Hundred
Years* and *A Thousand Years*, which are exhibited in
the group show *Gambler*, curated by Freedman and
Sellman. The works consist of two black-framed,
transparent tanks divided in two with a few small
openings in the glass connecting them. Inside the
tanks is a maggot-infested, severed head of a cow,
underneath an insect-o-cutor. As the maggots
metamorphose into flies, they are inevitably drawn
to the insect-o-cutor, which ends their lives.

1991

Hirst meets Maia Norman, his partner for the next
 nineteen years, with whom he has three children.

In June, his first solo show, *In and Out of Love*, opens
 at the Woodstock Street Gallery in London. The
 exhibition is curated by Tamara Chodzko and
 includes an artificial environment in which live
 butterflies breed and fly around, landing on the
 eight blank canvases hung on the walls, before
 eventually dying.

In December, Hirst's first solo exhibition in a public
 gallery *Internal Affairs*, opens at the Institute of
 Contemporary Arts in London.

1992

Hirst meets Gordon Burn, a writer who begins to
 interview him regularly.

Young British Artists I, the first exhibition in a series
 of group shows featuring Hirst, opens at the
 Saatchi Gallery in London. Hirst exhibits *The
 Physical Impossibility of Death in the Mind of Someone*

Living, a fourteen-foot tiger shark suspended in a formaldehyde solution.

Later this year, Hirst is nominated for the Turner Prize and exhibits with Grenville Davey (winner), David Tremlett, and Alison Wilding at the Tate Gallery in London.

In November, Hirst exhibits his 'twins' spot painting *Marianne, Hildegard* at Unfair/Jay Jopling, during Art Cologne.

In December, he exhibits *Pharmacy* at the Cohen Gallery in New York.

1993

Hirst is awarded the DAAD fellowship and residency in Berlin.

Mother and Child (Divided), a cow and calf dissected and halved, suspended in four separate tanks filled with formaldehyde, is selected for the 45th Venice Biennale.

With Angus Fairhurst, Hirst sets up his first spin painting stall in Hoxton Square, London.

In this year, Hirst and Fairhurst also create the short
film *A Couple of Cannibals Eating a Clown (I Should Coco)*.

1994
While in Berlin, Hirst creates his first spin machine.
In May, the group show *Some Went Mad, Some Ran
Away*, curated by Hirst (and titled after an essay by
Fairhurst), opens at the Serpentine Gallery in London
and travels to several other venues. During the exhibition, artist Mark Bridger vandalizes one of Hirst's
works, *Away from the Flock*, by pouring black ink into
the tank.
Later this year, Hirst creates the cover artwork for
Greetings from the Gutter by Dave Stewart.
Hirst buys the Yellaton House in Devon and splits his
time between London and Devon while the house
is being renovated.

1995
Hirst's first son, Connor, is born.
He is awarded the Prix Eliette (founded by Eliette von
Karajan).

In November, Hirst is awarded the Turner Prize and
exhibits alongside fellow nominees Mona Hatoum,
Callum Innes, and Mark Wallinger.
Later this year, Hirst directs the music video for "Country House," by Blur. The song reaches number one on
the UK charts.

1996

Hirst writes and directs the short film *Hanging Around*
for a group exhibition at the Hayward Gallery in
London.
In May, *Damien Hirst: No Sense of Absolute Corruption* opens at
Gagosian Gallery in New York.
Hirst moves to Devon.

1997

Hirst establishes Science Ltd. as his administrating
company.
Later this year, he creates his first fly painting, *Untitled
Black Monochrome (Without Emotion)*.

1998

With partners Matthew Freud, Liam Carson, and
 Jonathan Kennedy, Hirst opens Pharmacy, a bar and
 restaurant in London.

Also this year, Hirst forms the band Fat Les with Alex
 James and Keith Allen. Their song "Vindaloo" reaches
 number two on the UK charts and is the unofficial
 theme song for the 1998 FIFA World Cup.

1999

In February, the installation *Pharmacy* is exhibited at the
 Tate Gallery in London.

Hirst's first print portfolio, *The Last Supper*, is published
 by Paragon Press.

2000

Hirst's second son, Cassius, is born.

Also this year, Hirst acquires a new studio space in
 Chalford.

In September, editions of Hirst's twenty-foot sculpture
 Hymn are shown at Saatchi Gallery in London and
 Gagosian Gallery in New York.

2001

On the *Way to Work*, a book of twelve interviews between Hirst and Gordon Burn, is published by Faber.

Hirst is awarded the Grand Prize at the 24th International Biennale of Graphic Arts in Ljubljana.

Also this year, Hirst directs *Breath* (Beckett on Film) for Channel 4 and RTE.

2002

Hirst designs the set for *Glastonbury: The Play*, written by Zoë Lewis and directed by Keith Allen.

2003

In September, *Damien Hirst: Romance in the Age of Uncertainty* opens at White Cube Gallery in London.

In April, *Damien Hirst* opens at Saatchi Gallery in London as part of the new Saatchi Gallery at County Hall.

Pharmacy restaurant closes.

2004

In October, *Damien Hirst: The Agony and the Ecstasy*, Hirst's

first retrospective exhibition, opens at the Museo
Archeologico Nazionale in Naples.

Also in October, more than 140 items from Pharmacy
restaurant are auctioned at Sotheby's, London.

The auction's total sale price is £11.1 million.

Hirst acquires the White Hart Bar in Devon, which he
will turn into the restaurant The Quay.

2005

Hirst's third son, Cyrus, is born.

Hirst creates the publishing company Other Criteria
with Hugh Allen, Frank Dunphy, and Jason Beard.
The company focuses on limited edition sculptural
works, prints, and editions. Later this year, one of
their publications, *Damien Hirst: From the Cradle to the
Grave; Selected Drawings* (published in association with
the British Council), wins the Beaux Arts Magazine
Award for Best Art Publication.

Hirst buys Toddington Manor in Gloucestershire, as well
as three houses and land to build a studio space in
Mexico.

2006

In November, *In the Darkest Hour There May Be Light: Works from Damien Hirst's Murderme Collection* opens at the Serpentine Gallery in London. The exhibition includes works by Andy Warhol, Francis Bacon, John Currin, Tracey Emin, and Richard Prince, among others.

On November 9, Hirst gives up alcohol, smoking, and drugs.

2007

In June, *For the Love of God*, a platinum cast of a human skull encrusted with diamonds, is shown as part of the exhibition *Beyond Belief* at White Cube in London.

On June 21, Hirst achieves the highest auction record for a living artist. The work sold is *Lullaby Spring*, which sells for £9.6 million at Sotheby's, London.

2008

On September 15 and 16, 244 works from the exhibition *Damien Hirst: Beautiful Inside My Head Forever* are auctioned at Sotheby's, London, achieving £111,576,800.

For the Love of God is shown at the Rijksmuseum in
 Amsterdam.

2009
Hirst first exhibits his Blue Paintings series at the
 PinchukArtCentre in Kiev.

2010
In April, *Cornucopia*, a major solo exhibition, opens at the
 Oceanographic Museum of Monaco in Monte Carlo.
For the Love of God is shown at the Palazzo Vecchio in
 Florence.

2011
In January, *Damien Hirst: Forgotten Promises* opens at
 Gagosian Gallery in Hong Kong. The exhibition
 includes *For Heaven's Sake*, a platinum cast of an
 infant's skull encrusted with diamonds.
U2 headlines the Glastonbury Festival, accompanied
 by a video work created by Hirst.
Hirst also collaborates with Flea, the bassist of the Red
 Hot Chili Peppers, to produce a series of unique bass

guitars. The guitars each have an individual black-and-white or colored spin design, and proceeds from their sale go to Silverlake Conservatory of Music.

2012

On January 12, *The Complete Spot Paintings* opens at Gagosian Galleries in multiple locations worldwide.

In April, *Damien Hirst*, a retrospective solo exhibition, opens at the Tate Modern in London.

Hirst and Maia Norman split.

2013

Hirst designs the statue for the 33rd Brit Awards, held on February 20.

2014

In October, *Schizophrenogenesis* opens at the Paul Stolper Gallery in London.

2015

Hirst opens the Newport Street Gallery in London as part
of his long-term ambition to share his art collection
with the public.

2017

In April, *Treasures from the Wreck of the Unbelievable* opens
at the Punta della Dogana and the Palazzo Grassi in
Venice, Italy. Ten years in the making, the project is
exceptional in scale and scope. The exhibition tells
the fictional story of the ancient wreck of a large
ship, the *Unbelievable* (Apistos in the original Koine
Greek), and presents what was discovered of its
cargo.

An eponymous film released on Netflix traces the story
behind the project. Hirst collaborated with direc-
tor Sam Hobkinson and producer Nicolas Kent to
chronicle the exhibition's extraordinary backstory:
the discovery and excavation of the fictional ancient
shipwreck.

2018

In March, *Veil Paintings* opens at the Gagosian Gallery in LA. The veil paintings layer brushstrokes and bright dabs of heavy impasto, embracing color and gestural painting on a large scale.

In May, *Colour Space Paintings* opens at the Gagosian Gallery in New York. Evolving from the iconic Spot Paintings, the Colour Space paintings appear looser than the Spot Paintings, with Hirst's imperfect discs overlapping like particles under a microscope.

2019

In September, *Mandalas* opens at White Cube Mason's Yard in London. The Mandala series returns to one of his most well-known motifs—the butterfly—while taking inspiration from mandalas: highly patterned religious images that represent the cosmos or universe in Hindu, Buddhist, Jain, or Shinto traditions.

2020

In November, Hirst completes his monumental Cherry Blossoms series, canvases entirely covered in dense, bright colors that suggest a vast floral landscape.

2021

In July, Cherry Blossoms opens at the Fondation Cartier pour l'art contemporain in Paris.

In July, Hirst launches a non-fungible token (NFT) initiative titled "The Currency" with HENI, an international art services business founded by Joe Hage. The initiative involved selling 10,000 unique works on paper that each corresponded to an NFT. Collectors have one year to decide if they wish to keep the physical artwork and relinquish their rights to the NFT, or keep the NFT, in which case the physical artwork would be destroyed.

On September 3, Drake releases Certified Lover Boy with album artwork created by Hirst.

ACKNOWLEDGMENTS

First and foremost, my thanks go to Damien Hirst, whose words and thoughts comprise the basis of this publication. It is a true honor to be aligned with such an extraordinary artist and creative mind.

My sincere thanks to Aaron Shaw, Rachel Wiseman, Katherine Nisbet, Nathalie Agostini, and the entire team at Science Ltd. for their professionalism and valued assistance on our many endeavors. My special thanks as well to Joe Hage, Rodney Hare, Joe Harper, and the entire team at HENI.

My heartfelt appreciation to Princeton University Press, especially Christie Henry, Michelle Komie, Terri O'Prey, Cathy Slovensky, Kenneth Guay, Jodi Price, Laurie Schlesinger, and Kathryn Stevens. We remain extremely grateful to PUP for their continued professionalism, encouragement, and passion for our projects together throughout the years.

My sincere thanks as well to Vanessa Lee, Kevin Wong, Keith Estiler, Rickey Kim, Molly McCommons, Man Huang, Hassan Ali Khan, Jan Prasens, John Pelosi, Angelo DiStefano, John Cahill, and Haisong Li for their global support. Thanks also to Louise Donegan and Mike Dean for their creative inspiration.

Special thanks to Fiona Graham for her invaluable research and organization of this publication. My thanks as well to Matthew Christensen and Susan Delson for their excellent editorial support.

My sincere thanks to Taliesin Thomas for her amazing assistance with many projects and to Steven Rodríguez and Zara Hoffman for their continued support.

Finally, I give all my bottomless gratitude to my amazing wife, Abbey, and to my wonderful children, Justin, Ethan, Ellie, and Jonah, for their love and encouragement.

As always, I give endless love and thanks to my mother, Judith.

LARRY WARSH

Damien Hirst was born in Bristol, England, and lives and works in London, Devon, and Gloucestershire, England. Collections include the Museo d'Arte Contemporanea Donnaregina, Naples, Italy; Museum Brandhorst, Munich; Museum für Moderne Kunst, Frankfurt am Main, Germany; Stedelijk Museum, Amsterdam; Centro de Arte Dos de Mayo, Madrid; Tate, London; Israel Museum, Jerusalem; Astrup Fearnley Museet, Oslo; Gallery of Modern Art, Glasgow, Scotland; National Centre for Contemporary Arts, Moscow; Museum of Modern Art, New York; Hirshhorn Museum and Sculpture Garden, Washington, DC; Art Institute of Chicago; The Broad, Los Angeles; Museo Jumex, Mexico City; and 21st Century Museum of Contemporary Art, Kanazawa, Japan. Exhibitions include Cornucopia, Oceanographic Museum of Monaco (2010); Damien Hirst, Tate Modern, London (2012); Relics, Qatar Museums Authority, Al Riwaq (2013); Signification (Hope, Immortality and Death in Paris, Now and Then), Deyrolle, Paris (2014); Damien Hirst, Astrup Fearnley Museet, Oslo (2015); The Last Supper, National Gallery of Art, Washington, DC (2016); Treasures from the Wreck of the Unbelievable, Palazzo Grassi and Punta della Dogana, Venice (2017);

Damien Hirst at Houghton Hall: Colour Space Paintings and Outdoor Sculptures, Houghton Hall, Norfolk, England (2019); *Mental Escapology*, St. Moritz, Switzerland (2021); *Cherry Blossoms*, Fondation Cartier, Paris (2021); and *Archaeology Now*, Galleria Borghese, Rome (2021). Hirst received the Turner Prize in 1995.

Larry Warsh has been active in the art world for more than thirty years as a publisher and artist-collaborator. An early collector of Keith Haring and Jean-Michel Basquiat, Warsh was a lead organizer for the exhibition *Basquiat: The Unknown Notebooks*, which debuted at the Brooklyn Museum, New York, in 2015, and later traveled to several American museums. He has loaned artworks by Haring and Basquiat from his collection to numerous exhibitions worldwide, and he served as a curatorial consultant on *Keith Haring | Jean-Michel Basquiat: Crossing Lines* for the NGV. The founder of *Museums Magazine*, Warsh has been involved in many publishing projects and is the editor of several other titles published by Princeton University

Press, including *Basquiat-isms* (2019), *Haring-isms* (2020), *Futura-isms* (2021), *Abloh-isms* (2021), *Arsham-isms* (2021), *Warhol-isms* (2022), *Jean-Michel Basquiat: The Notebooks* (2017), *Keith Haring: 31 Subway Drawings*, and two books by Ai Weiwei, *Humanity* (2018) and *Weiwei-isms* (2012). Warsh has served on the board of the Getty Museum Photographs Council and was a founding member of the Basquiat Authentication Committee until its dissolution in 2012.

ILLUSTRATIONS

Frontispiece: Damien Hirst photographed by David Bailey, © David Bailey

Page 104: *The Physical Impossibility of Death in the Mind of Someone Living*, 1991 (three-quarter view) © Damien Hirst and Science Ltd. All rights reserved / DACS, London / ARS, NY 2022. Photo: Prudence Cuming Associates Ltd

ISMs
Larry Warsh, Series Editor

The ISMs series distills the voices of an exciting range of visual artists and designers into captivating, beautifully made books of quotations for a new generation of readers. In turn passionate, inspiring, humorous, witty, and challenging, these collections offer powerful statements on topics ranging from contemporary culture, politics, and race, to creativity, humanity, and the role of art in the world. Books in this series are edited by Larry Warsh and published by Princeton University Press in association with No More Rulers.